Picture Southern Oregon

LANDMARKS OF A NEW GENERATION

© 2004 Annie M. Edlen Foundation

All rights reserved. No part of this book may be reproduced in any form or by any electronic or mechanical means including information storage and retrieval systems without permission in writing from the publisher, except by a reviewer.

Published by Story Line Press, Three Oaks Farm, PO Box 1240, Ashland, OR, 97520-0055, www.storylinepress.com.

This publication was made possible thanks to the Annie M. Edlen Foundation.

Cover photo by Cara Clemens
Book design by Sharon McCann

• • •

Library of Congress Cataloging-in-Publication Data
Picture southern Oregon : landmarks of a new generation /
Steven Good ... [et al.].
p. cm.
ISBN 1-58654-033-5
1. Oregon—Pictorial works. 2. Oregon—History, Local—Pictorial works. 3. Oregon—Social life and customs—Pictorial works.
4. Child photographers—Oregon. I. Good, Steven.
F877 .P53 2004
979.5'2'00222—dc22
2003017489

Picture Southern Oregon

LANDMARKS OF A NEW GENERATION

Cara Clemens

Hannah Cross

Sean Culhane

Brendan Good

Juan Pablo Rivera

Marshall Spring

Tiger Torelle

Necia Wilkerson

and

Steven Good

• • •

Story Line Press

Ashland, Oregon

To Karen, my world

Contents

6 ... What is a Landmark? *Susan Rubinyi-Anderson*

8 ... Picturing Southern Oregon *Steven Good*

11 ... The Photographs

94 ... Afterword *Herb Heiman*

97 ... Biographies

...What is a Landmark?

In December of 1997, I had the great pleasure of visiting the new Getty Center. After enjoying its travertine stone architecture and panoramic overview of the city, I viewed a film on various Getty-funded projects. The project called "Landmarks of a New Generation" immediately caught my attention. Students were given cameras to document landmarks of their neighborhoods. What emerged were highly individualized photographic and verbal "maps" of their worlds. The project then expanded worldwide to include young peoples' photographic portraits of LA, Paris, Mexico City, Cape Town, and Mumbai.

A year later I found myself in LA again, faced with an assignment that was also a conundrum—to continue my work with non-traditional gifted populations in Southern Oregon at a geographic distance of several hundred miles. In search of ideas for possible projects as well as moments of meditative calm from the urban tumult, I visited the Getty Research Institute Library.

As I read through projects, I came across the Landmarks books. Leafing through *Picture Paris,* I both relived my years in France plus saw the city as vastly different microcosms, reflecting the perspectives of the young

photographers. My enthusiasm grew as I traveled vicariously through Mexico City, Mumbai, and Cape Town, and I decided to arrange an appointment with the original Project Director, Mahasti Afshar, of the Getty Conservation Institute. I found her inspiring, helpful, encouraging. As we spoke, I raised a potential concern:

"Could a Landmarks project be done in a rural area? Southern Oregon has great natural beauty—forests, countryside, oceans—but no major cities on the scale of Paris or Mexico City."

"It doesn't matter," she reassured me. "As a matter of fact, we had been thinking about the possibility of expanding to less populated areas after the first series of books."

More confident and armed with the Getty's very detailed "how to" project manual, I was ready to face the next challenge. The project seemed to fit within the Annie M. Edlen Foundation guidelines of a mentoring situation for non-traditional gifted kids, but where would I find a professional photographer interested in becoming Field Director?

"Steven Good," I thought, remembering our many conversations on innovative approaches to gifted education. Containing my enthusiasm, I called Steven. To my delight, he was open to the idea.

"When do we start?" he asked.

At first, the manual of detailed steps seemed overwhelming. Selecting the photographers was only the first step—we also had to think in terms of a photographic exhibition as well a book publication. But gradually, the project began to assume shape. Through Steven's inspired direction, the aspiring young photographers began to explore the landmarks of their personal landscapes within the larger landscape of Southern Oregon.

Susan Rubinyi-Anderson
Project Director and Program Planner
Annie M. Edlen Foundation

...Picturing Southern Oregon

When my friend Susan first approached me with the idea of producing a Landmarks book about Southern Oregon, I must admit that my emotions ran the gamut. On one hand, I was thrilled with the idea of teaching photography to middle- and high school-age students. I have been involved in photography since I was about eight years old when I began to use my father's darkroom in the basement of our Long Island home. On the other hand, I could not imagine who would be interested in such a book. After all, the previous Landmarks books were about large cities, such as LA, Mexico City, and Paris. How could the sights of our part of the world compare with the Eiffel Tower or the streets of Hollywood?

As I thought more and more about the project, I concluded that, for many of us, where we live influences who we are. Didn't I consciously make the decision to move here? To live and work here? To raise my son here? I began to think for the first time in terms of what this area we call Southern Oregon has to offer. From the crashing waves along the coast, to the high volcanic peaks of the Cascade Mountains, to the ancient trees of our forests, our region is one of incredible scenic diversity. What better way to show it off to the rest of the world than through the eyes of its

young inhabitants. After doing research on what a landmark meant to me, I felt I was ready to make the commitment.

My first test was selecting kids who were gifted in their unique ways. I started putting out "feelers," contacting individuals involved in education, theater, sports, and 4-H clubs. The main criteria was their interest to be involved in such a project. They did not need to know a thing about photography! This sounds strange for a photography project, I know, but one of the goals was to teach photography basics to talented adolescents.

The group we put together was super. They were public, private and home-schooled students, ranging from middle-school age to high-school seniors. Their interests were as varied as their education—theater, computer, animals, travel, family, and of course their friends.

Once our group was selected, each participant was given a Pentax point and shoot camera with a zoom lens and a photography lesson. We covered everything from the proper way to hold a camera and load the film to composition and lighting. We continued to meet frequently as a group at our favorite dessert hang out—Mac's Diner in Medford. Each meeting was intended to offer guidance in the picture-taking process as well as address individual questions about photography. I introduced different aspects of photography and tweaked their creativity just a bit more. Tripods were passed around and picture "croppers" helped them to see what a favorite picture would look like in its final size. Announcements were made about upcoming events in our area that would provide good material for picture-taking. I worked closely with each photographer to help them pick their best shots for the book. Hearing their words about why they took each picture was very enlightening for me—allowing me to see my adopted home, Southern Oregon, through the eyes of talented and clever teens.

Photography began as a way to document what was happening around us and around the world by photographers such as Edward Curtis and Jacob Riis. In the 20th century, masters such as Ansel Adams and David Muench added a new dimension to photography—the art form. I like to think that the work produced by the young photographers represented in this book combines both the documentary and artistic forms of photography.

I personally thank the parents of these very capable teens. They shared many interesting aspects of their lives with me as we worked together, which I could not have done without your support. Enjoy the book!

Steven Good

Field Director

Map of Southern Oregon © AAA, used by permission. ▣ indicates where photographs were taken.

THE PHOTOGRAPHS

...Cara Clemans

WHAT IS A LANDMARK TO ME?

A landmark is a place that makes you happy and has meaning to you. It's where you go to get away and relax. It is a place you can travel to and have fun.

14
...

MILL CREEK FALLS . . . The waterfalls here are so loud and powerful.

16

17

18

STREET SCENE . . . Even with its old age and all the storms it has endured, this building is still standing.

19

20

OREGON COAST . . . This part of the coast is very quiet and beautiful. Not many people know it is there, because you have to do a great deal of walking and climbing to find it.

. . . Hannah Cross

WHAT IS A LANDMARK TO ME?

My idea of a landmark is something or someone that reminds me of where I have been. It's a point, a place or a person that I'll remember, and will bring back a special feeling or memory.

ARCH SEA STACKS . . . This photo is of rock arches off the Southern Oregon coast. There are similar arches all along the coastline.

25

SAVAGE RAPIDS DAM . . . This is a photo of the Savage Rapids Dam on the Rogue River between Grants Pass and Rogue River. There has been controversy over whether or not to remove the dam because of its effect on the salmon migration.

28

ROOSTER CROW . . . The town of Rogue River holds an annual Rooster Crow parade. It is held the last Saturday in June and includes a parade, rooster crowing contest, carnival, and other things. This photo is of a man taking part in the parade, dressed as a lobster.

30

... *Sean Culhane*

WHAT IS A LANDMARK TO ME?

Landmarks are like a safe-house of memories, because when you see them, memories flood to you out of the darkness. When I see landmarks, I know that they will be around for awhile for a lot of people to see. They give a certain sense of history sometimes and they always bring a bit of personality to where they stand. Landmarks give us the opportunities to see some of Southern Oregon's finest places.

35

LITHIA BEARS . . . This statue lies behind the El Tapatio restaurant. It is very pleasing to the eye. It really catches your interest.

37

SHAKESPEARE CENTER . . . I like the angle on this photo. You can see the box office of the Oregon Shakespeare Festival and the sign that shows what is playing in each theater.

39

STREET ARTISTS . . . This is a man selling masks at the outdoor craft market held every weekend starting in the late spring and ending in the late fall. It is held on Guanajuato Way.

GRIZZLY PEAK . . . This is a picture of a mountain you can see from outside my old house. Although I am not sure how it got its name, I really enjoyed the great view.

... Brendan Good

WHAT IS A LANDMARK TO ME?

I think that a landmark is something that is important to you, and something that can directly impact you. It can be something that you can see everyday, or it can be a special place that you only see on the weekends. A landmark is something that you will always remember. It could be as significant as a mountain, or a bird in a nest. A landmark is something that you give value to, even if you are the only person seeing, hearing, tasting, smelling, or touching it.

43

44

COAST . . . This photo was taken along the Oregon coast. In Oregon, unlike California, there are fewer sandy beaches, and the 300 miles of coastline are mostly rocky. The entire Oregon coast is owned by the state, allowing unlimited access. There are many beautiful viewpoints to go whale-watching, to hike, and just to play in the sand.

DARCY

SHADOWS... This photograph shows the closeness of my family, which is probably my most important landmark. It was taken near Ashland Creek in Lithia Park. Lithia Park is a centrally located place for families or individuals to do anything from sit in the shade to play baseball. The park is over 100 acres of beautifully landscaped grounds with playgrounds, tennis courts, volleyball nets, and miles of walking trails.

FOURTH OF JULY . . . Every year, large crowds of people gather on the plaza in Ashland to watch the annual Fourth of July parade. It is a time for talented people to do anything from ride unicycles, create enormous soap bubbles, and play in marching bands. It is a great time to meet friends. After the parade, there are over 100 different craft and food booths in Lithia Park. Live music is performed throughout the day at the Butler bandshell.

49

50

TREE . . . Trees are a very important part of my life, not only because I live in Oregon, but because I live and play around them daily. This tree is an old-growth Douglas fir. It is over 200 feet tall and 500 years old! Trees are important in our lives because they make oxygen and food. They also supply us with a place to live.

CRATER LAKE . . . Crater Lake is the only national park in the entire state of Oregon. It was formed thousands of years ago by a volcano, and is actually a very deep lake in the caldera. There is a lodge on the rim, and many miles of cross-country skiing and hiking trails that lead off into the woods.

...Juan Pablo Rivera

WHAT IS A LANDMARK TO ME?

The word "landmark" is very significant to me for many reasons. For one thing, I use the word landmark to describe a landscape that has significance in my life. I use the word to describe a significant event, scene, or site that I always want to remember. I think a landmark is something I will always want to see and never get bored of observing. I will always enjoy observing my favorite landmarks of the Rogue Valley as though I am seeing them for the first time.

55

FOLKLORICO . . . This photo was taken at the annual Cinco de Mayo celebration at Hawthorne Park in Medford. The event demonstrates the many different cultural celebrations that take place in the Rogue Valley.

57

SMUDGE POTS . . . This photo was taken in Talent, Oregon, at the Royal Crest Orchard. Smudge pots are utilized during the cold nights of spring to keep the pear blossoms from freezing.

59

60

PEAR TREE IN BLOSSOM . . . This photo was taken in Phoenix. It represents one of the most common fruit trees grown in the Rogue Valley.

PHOENIX HILLS . . . This is just a sampling of the beautiful landscape scenes that surround the Rogue Valley.

...Marshall Spring

WHAT IS A LANDMARK TO ME?

Landmarks come in many shapes and sizes. A landmark can be found in a person, place, or event. When I think back on my life there are many landmarks that come to mind. My family and friends, my school and teachers, the places I have worked and played, and the unforgettable events that have shaped my life. Many people seem to believe that something has to be old to be a landmark. I don't agree. To me landmarks are anything that has profoundly affected your life in some way. It can be an old farm that you have always driven by but never been in, or it can be the one time as a child you almost drowned and your life flashed before your eyes. A landmark is something you take with you forever and has a hand in shaping the person you are today.

65

67

MOM AND FRIENDS . . . This is a photo of my mom and her friends sitting and enjoying one another's company on a warm spring afternoon. As prominent artists in the Rogue Valley, these ladies serve as landmarks for many people in the community. For me, however, they serve as much more. Sarah Spring, second from the left, is not just a landmark, she is my mother and her friends make a much valued extended family.

ASHLAND'S FINEST . . . One of Ashland's finest police officers, Teri DeSilva, takes time from her workday to pose for a picture, while increasing public relations between youth and the police department.

TWO BIKES . . . Landmarks come in many different forms. Last year, a friend and I took a one-week bicycle trip down the Pacific coastline. This photo is of our bikes parked outside a growers' market near Talent where we stopped during one of our training rides.

VIDEO . . . Here, my friends and I are shooting a video for a student produced television program "Ashland High Live." We created this show to keep local high school students involved in events, concerts, and anything else happening in their community.

73

... Tiger Torelle

WHAT IS A LANDMARK TO ME?

A landmark can be many things. It can be very personal, such as an old house you used to live in, or it can be just something to point you in the right direction, like a street sign. A landmark is an image that is hard to forget. Or it is something that is noticeable and sticks out in your mind. It can help guide you to where you want to go or help you remember where you have been. Because it can be so many things, it is whatever you say it is.

75

76

AMERICAN FLAG . . . This is simply a picture of an American flag. You can find American flags hanging all over the Rogue Valley especially on holidays.

STATUE . . . This was taken at one of the many graveyards in Southern Oregon. There are many intricate statues like this one at most graveyards in the Rogue Valley.

PICKET FENCE . . . This is a picture of what a neighborhood in the historic district looks like. It was taken on B Street in Ashland.

...Necia Wilkerson

WHAT IS A LANDMARK TO ME?

Landmarks represent a memory, like a symbol on a map. In Southern Oregon, my map has been blessed with many marks—the marks of beautiful swimming holes, intense soccer matches, and wonderful people. Everyday, memories, good and bad, make marks on my map called life, and I was lucky enough to include a few photographs of those landmarks in this project. Sharing my landmarks and helping prove why Southern Oregon is one of the neatest places to live has been one of the greatest projects I've had the luck to be involved in. This book will forever be a landmark in my life.

83

EAGLE STADIUM . . . Many a good time was spent at this stadium in Eagle Point, Oregon. Football games, track meets, homecoming parades, Fourth of July firework shows, and graduations have all packed the stands in this little rural town. There have been marriages proposed and championships won. This one little stadium holds much meaning in this little town.

85

86

MIA HAMM FANS . . . Mia Hamm is every soccer-playing teenage girl's idol. These girls wear her jersey proudly as they watch a soccer match.

BUMPER STICKER . . . Proud ranchers decorate their trucks with "puny" sayings. The truth is though, their meat is unbeatable.

TOY TRACTOR . . . A little John Deere. Every little boy should have one.

91

BEST FRIENDS . . . Here are three of the best friends put on this earth. This picture brings back memories of high school and just hanging out. No midterms or finals, no work or loans. Just goofing off and building life-long relationships.

... *Afterword*

What is the use of an afterward given that you have already *read* the book? This query tantalized me and teased my synapses until the answer simply arrived. An afterward should make the reader want to look at the book again and again. These extraordinary black and white impressions are views of rural America seen through the lenses and senses of tomorrow's Southern Oregon adults.

Look at the photographs for what they are and connect with what they make you feel. There is a common thread woven through them. Most aim straight at the heart of simpler times, days of summer's stillness, winter's solitude, and spaces that wear the clothes of seasons. Oh, there is a side of Southern Oregon that is neon, malls, fast food, and glitz. However, these young artists turn inward toward the beauty of their natural surroundings: shadows, shapes, tree trunks, meadows, and sights that sing of the land.

SOME EXAMPLES

Not far from where I used to live in Prospect, Oregon is a picturesque waterway called Mill Creek. As you approach it from the bend of a dirt trail, it spills its energy with a deep roar. It is here that Cara Clemans turned her camera onto twin sheets of cascading water. Or are they burning infernos

of rising flame? Falling or rising, this shot is an indelible glimpse of Southern Oregon, along with the Cascade mountain portrait, revealing a rugged yet tranquil landscape that whispers of peace. Her gauzy Lithia Park impressions are unfocused dreams, visions of life spun from the texture of fantasies.

Brendan Good subtly captured a weathered, cryptic tree trunk as it soars beyond this realm reaching toward eternity. His other wooden subject, a stump in snow, cries of its lonely and barren death. But beneath the snow is the promised renewal of spring hidden just weeks away. Even the thought takes one's breath away.

Juan Pablo Rivera's striking photo of Phoenix hills is a carpet of gentle rolling landscape whose melody haunts me. It sings of the land. The Phoenix hills are where I live and what I see every day as I peddle through this idyllic countryside on my bike.

Here there is also the faded face of rustic Americana. Not a movie set or theme park attraction but a country store and junk shop by Marshall Spring, which was and is a striking landmark of frontier commerce that existed for several hundred years in most every corner of our country. Remarkable picture, remarkable memory, remarkable piece of living history.

We are invited to linger with the intriguing contrasts of light and dark, of elongated shadows, and glimpses into the world of Hannah Cross' startling mini-drama, still life. You can almost see her half-eaten apple waiting off camera for the next picture. When the Canadian geese take flight, Hannah asks, "Where are you off to, you perennial wanderers?" On the ground their cousins the geese look directly at us and ask, "Who and what are you?" Who and what indeed?

At the gates of the unknown, Tiger Torelle's camera shudders at the entry to a fortune teller's house, whose sign says "Tis the season of the witch." Tiger found a doorway that beckons us to the past, the present, and perhaps the future. Looking at picket fences, one can almost view infinity as the white slats drift into the horizon.

What rustic photo collection would be complete without the battered windmill caught in permanent disrepair by Necia Wilkinson? It stands alone, a symbol of shattered dreams and the faint possibility of hope. The country fair needs no explanation to those who have smelled the cotton candy, heard the shrieks of young girls trapped atop the ferris wheel, or inhaled the time of a simpler life.

Sean Culhane takes us on a visit to his environment of familiarity and comfort. Likely from his bedroom

window, he snapped a view of rugged Grizzly Peak. In town he drifts, camera in hand, noticing street vendors plying their trade, statues and fountains, the Elizabethan Theater—each a piece of the puzzle of our artsy-craftsy community of Ashland. Sean Culhane is a child of this culture and his photos take us on an excursion of his charming and inviting home.

Each of our eight artists reveals about themselves more than they could have imagined. Their photos reveal their eye for beauty, search for truth, and dreams for tomorrow. How wonderful to revisit these artists in several years, to see their new sets of prints and witness their footprints upon the earth.

Herb Heiman

Talent, Oregon

BIOGRAPHIES

. . . *Cara Clemens*

Cara was sixteen-years-old while working on the project. Born in Tacoma, Washington, she moved to Southern Oregon several years prior to its start. Home schooled during middle and high school, she now attends classes at Rogue Community College in Medford. Her interests include photography and drawing.

. . . *Hannah Cross*

Hannah was a fourteen-year-old, 8th grade student at Rogue River Middle School at the time of the project. She is now being home schooled. Her hobbies are reading, horseback riding, babysitting for her niece, and taking care of the family pets. Hannah also volunteers at Rogue Valley Medical Center, Washington Campus, a few hours a week.

... Sean Culhane

Sean was born in Puerto Rico on July 8th, 1987. In 1989, he moved with his family to California, then to Florida and eventually to Southern Oregon. Sean is being home schooled, as well as attending classes at the Ashland Community Learning Center. His hobbies include video games, animation, Flash 4, and computers.

... Brendan Good

Brendan has lived his entire life in Southern Oregon. He was 13-years-old at the time of the project and attending a private middle school in Medford, Oregon. He has just finished his freshman year of high school. In his spare time he enjoys reading, hiking, baseball, travel, kayaking, and computer games. Brendan says "taking photos is a great way to express yourself, and to share your community and surrounding areas with others."

... Juan Pablo Rivera

Juan was 18-years-old at the time of the project. He graduated from Phoenix High School and is attending classes at Rogue Community College in Medford. His interests include photography, astronomy, and collecting automobile models. He plans to study at Southern Oregon University in Ashland and aspires to be a lawyer.

... Marshall Spring

A senior at Ashland High School while participating in the project, Marshall was born in Steamboat Springs, Colorado. He has lived in Ashland for 15 years. Living in a theater town rubbed off on Marshall. He has been very involved in theater both in front of the audience and at the technical level. Marshall recently joined the United States Marines and hopes to use the GI Bill to study acting upon his discharge from the military.

. . . Tiger Torelle

Tiger Lee was an 8th grade student at Ashland Middle School during the project. She was involved in soccer, basketball, and middle school speech team. Tiger just finished her freshman year at Ashland High School. She played Winthrop in the spring musical "The Music Man." Someday, she hopes to attend UCLA and become an actress.

. . . Necia Wilkerson

While participating in the project, Necia was a senior at Eagle Point High School and an avid soccer player. She has lived in California, England, and Texas, as well as Southern Oregon for twelve years. She feels Southern Oregon is the most beautiful place she has ever lived. After spending one year at college in Tennessee at Milligan College, Necia returned to Oregon and is taking classes at Rogue Community College. Her major is education and she plans to be active as a soccer coach.

Susan Rubinyi-Anderson Steven Good Herb Heiman